THE GUERILLA ART KIT

Published by
Princeton Architectural Press
37 East Seventh Street
New York, New York 10003

For a free catalog of books, call
1.800.722.6657.
Visit our website at www.papress.com.

© 2007 Keri Smith
www.kerismith.com
All rights reserved
Printed and bound in China
10 09 7 6

Editing: Clare Jacobson and Nicola Bednarek
Design: Deb Wood

Special thanks to: Nettie Aljian, Sara Bader,
Dorothy Ball, Janet Behning, Becca Casbon,
Penny (Yuen Pik) Chu, Russell Fernandez,
Pete Fitzpatrick, Jan Haux, John King,
Nancy Eklund Later, Linda Lee, Katharine
Myers, Lauren Nelson Packard, Scott Tennent,
Jennifer Thompson, Paul Wagner, Joseph
Weston, and Deb Wood of Princeton
Architectural Press —Kevin C. Lippert,
publisher

Library of Congress Cataloging-in-Publication
Data
Smith, Keri.
 The guerilla art kit / Keri Smith.
 p. cm.
 Includes bibliographical references.
 ISBN-13: 978-1-56898-688-3 (alk. paper)
 ISBN-10: 1-56898-688-2 (alk. paper)
 1. Street art. 2. Wall drawing (Conceptual
art) 3. Handicraft. I. Title.
 TT157.S537 2007
 751.7'3—dc22

 2006037151

DISCLAIMER: THIS BOOK IS A BOOK OF IDEAS AND
CONCEPTS ON THE SUBJECT OF PUTTING WORK/ART
OUT INTO THE WORLD. NEITHER I NOR THE PUBLISHER
IS RESPONSIBLE FOR ANY ACTIONS THAT WERE
CREATED OR IMPLEMENTED AS A RESULT OF READING
THIS BOOK. (READ: YOU ARE ON YOUR OWN.) I AM ALSO
NOT RESPONSIBLE FOR THE CONTENT OF ANY WEBLINK
SET IN THE BOOK.

THE GUERILLA ART KIT

LOOK INSIDE

BY KERI SMITH

PRINCETON ARCHITECTURAL PRESS
NEW YORK

To J.D.P.
MAY WE CONTINUE TO DANCE AND
EXPLORE TOGETHER UNTIL WE ARE
OLD AND GRAY.

THANK YOU

TO MY AGENT FAITH HAMLIN FOR BELIEVING
IN THE IDEA; TO CLARE JACOBSON FOR JUMPING
IN FEET FIRST; TO NICOLA BEDNAREK AND
DEB WOOD FOR ALL YOUR HARD WORK; TO
STEVE LAMBERT FOR INSPIRING ME; TO
GAYLA TRAIL, MY GARDENING EXPERT; TO
LARNIE FOX, MY DICEWALKING EXPERT;
TO MIKE SCHWARTZ, WHO WAS WITH ME
THROUGH IT ALL (AND WHO IS A WONDERFUL
DANCER); TO PAULINE OLIVEROS FOR
TEACHING ME HOW TO SIT AND LISTEN;
TO CHRISTIAN KIEFER FOR LIKING ALL MY
IDEAS; AND TO ALL MY FRIENDS AND
FAMILY WHO CONTINUE TO SUPPORT ME.

"IT IS SOMETHING TO BE ABLE TO PAINT A PARTICULAR PICTURE, OR TO CARVE A STATUE, AND SO MAKE A FEW OBJECTS BEAUTIFUL; BUT IT IS FAR MORE GLORIOUS TO CARVE AND PAINT THE VERY ATMOSPHERE AND MEDIUM THROUGH WHICH WE LOOK. TO AFFECT THE QUALITY OF THE DAY—THAT IS THE HIGHEST OF ARTS."

—HENRY DAVID THOREAU

EXERCISES 51

TEMPLATES 117

QUOTES

INTRODUCTION

Sitting in the front seat of a cozy café I glance mindlessly at a lamppost outside the window. Perched about eight feet up on the post is a small group of fruit paintings (apples, peaches, pineapple, cherries) that I might not have noticed had I not drifted off in my thoughts, eyes wandering upward. Walking down the street on a sunny day I look down and spot a discarded bike frame, wheels missing, that has been covered in blue wool--transformed. I glance up at a chain-link fence that some interesting soul has decorated with found leaves; colors threaded in and out of the links. Adhered to a brick wall is a small white sticker with the word "think."

Modern culture with its overwhelming wealth of advertising, mass media, and mass communication often teaches us to tune out, or disconnect, because there is a limit to how much information we can process on a given day. In many cases we have no choice about the quality or quantity of what we take in. In an urban environment it becomes necessary to form a direct connection with the landscape, with aspects of the natural world, or with a greater community. Creating street art is one way to foster that connection. By adding to the

landscape I am reclaiming it as my own--I am now an active participant in how it operates and a partial creator of its complex language.

As a street art enthusiast I find myself searching for examples of artists leaving their marks in anonymous and subtle ways. I get excited knowing that the artist and I share a little secret. For a moment I am taken out of my known world and presented with an alternative, one that is unexpected and daring, one that makes me think about the space a little differently. These little gestures encourage me to not take our world so seriously, to contemplate for a moment something outside the predictable. They reawaken a sense of connection to the environment by pointing out something I might not have seen, by adding a new image to the world that is unexpected, or by presenting an alternate point of view.

WHAT IS GUERILLA ART?

The stereotype of the guerilla artist is someone
who makes extremist work and who is constantly on
the run from the law. For the purposes of this
book I would like to expand the concept and define
guerilla art as any anonymous work (including but
not limited to graffiti, signage, performance,
additions, and decoration) installed, performed,
or attached in public spaces, with the distinct
purpose of affecting the world in a creative or
thought-provoking way.

What motivates someone to put something out
into the world in this way? Why do it?

Early humans were drawn to express themselves
by drawing on cave walls, producing the first
evidence of guerilla art. People have always felt
the need to share and express themselves in a
public way, sometimes by telling a story or posing
a question, many times by presenting a political
ideology. Throughout history we have seen recurring
examples of this in political cartoons, street
theater, graffiti, political posters, crayon drawings
on walls, doodles in the margins of textbooks,
or writings in the dust on the windshield of a
dirty car. A series of drawings was recently
discovered in California, carved into a grove of
aspen trees. It was determined that they were

created by Basque sheepherders during the 1930s who were expressing their loneliness by carving words or images of nude women onto the trees.[1]

In the 1980s many street artists such as Jean-Michel Basquiat and Keith Haring entered into mainstream galleries and museums. The essence of their work did not change, only the context in which it was viewed. But did it lose something in the transition? A part of what makes public art interesting is how it interacts with its immediate environment. Picture a sticker with a colorful character posted on a construction wall. The character becomes a part of the landscape; we develop a relationship with him that revolves around our use of the space itself. Some guerilla artists are motivated by the need to take art out of the galleries and into the hands of the people. To relegate art to a gallery makes it available only to certain people, usually those with money. Guerilla art is for everyone. It engages viewers who might never step foot in a gallery. It is free and accessible.

The recent political climate in the U.S. has left many individuals feeling like they have no say, powerless to a system that seems to be dominated by corruption and money. Growing mistrust in corporate media has created a need for alternatives. Consequently, independent media such as weblogs, indie news, public art, and street art have become a rapidly

growing trend, a way for people to take power back. Guerilla art is one way of sharing a political ideology. It is a form of propaganda often utilized by the artist, but open to anyone. Guerilla art offers an alternative to the glut of corporate imagery we are faced with every day in the form of advertisements urging us to buy stuff. It can actually alter and add to the cultural landscape of an area. Many artists see it not only as a form of personal expression but also as a way of creating community in their neighborhoods.

I do not personally attempt to make work with an overt political message (though sometimes that does occur). Instead I let the medium itself be the political act. For me being a guerilla artist is a way of bonding with and reclaiming my environment. I become an integral part of public space instead of feeling like a visitor in my own city--walking through it but not affecting it in a literal way. In this way I am also questioning what is acceptable behavior and challenging what I am "allowed" to do within a specific context.

Guerilla art can be used to beautify or recreate a space that is soulless or without character and bring it new life. Picture sidewalk cracks on a busy street in the financial district that have been seeded with wildflowers. Or the chain-link fence woven with colorful dried leaves.

According to the magazine Adbusters, "Public art says 'the human spirit is alive here.'"

Guerilla art can be anything you want--an idea, an expression, a movement, an experience, an outlet, a way of connecting, a way of documenting, a challenge, a form of play, a statement, a performance, an attitude, a practice, an improvisation, a ritual.

FINDING YOUR INNER GUERILLA ARTIST

Becoming a guerilla artist is one way of embodying the famous Gandhi quote, "Be the change you want to see in the world." As an individual you can directly impact your environment on a regular basis. You can affect someone's day or even change the world (one interaction at a time) just by presenting someone with something different than what they might expect. Like a random act of kindness, guerilla art has the potential to create a ripple effect. Imagine the postal worker running through his day, stopping for a moment to read a quote you have chalked onto the sidewalk. You have the power to enter into people's daily routines.

Being a guerilla artist is secretive and exciting. There is a wonderful feeling of elation when you go out and place an anonymous gift, attach a painting to a park bench, leave a book behind in a public restroom. Just knowing that someone might find it gives you a feeling of anticipation. This can make it habit-forming!

This book is intended to introduce guerilla art and its various formats and to serve as a launching pad for your own ideas and methods. Each exercise is intended as a prelude to a specific medium and will present you with a few ideas to get you started. As there are many artists who can

offer more detailed and technical explanations of some of these processes, I have tried to include additional resources when possible. I encourage you to investigate further. This kit includes everything you need to start putting your ideas out into the world. There are dozens of methods, recipes, templates, ideas, and exercises. From the quick exercises--leaving books for strangers to find or chalking quotes on the sidewalk--to the more involved--making a "wish tree," guerilla gardening, or making your own stencils--*The Guerilla Art Kit* is about leaving your mark.

A WORD ON THE VALUE OF IMPERMANENCE

What is the point of a piece that is meant to be temporary? All of the exercises in this book are meant to be done as temporary installations. Work that is impermanent reminds us that nothing in life is permanent, that every state is temporary and transitory. Contemplating this concept teaches us to embrace change in our life, instead of working against it. When others notice a piece that is there one day and gone the next it creates a certain kind of energy/excitement within the community. It allows viewers to partake in the experience as a kind of detective, wanting to uncover the mystery.

Creating work that is impermanent helps us release our own attachment to the final product and lets us focus more on the process. I challenge you to make pieces with the idea of impermanence in mind (for example, creating a piece that changes in an interesting way when dampened by rain).

WHAT DO YOU WANT TO SAY?

You do not necessarily need to be able to draw or paint to be an artist. You only need to care about something. The biggest hurdle in creating guerilla art is not always how to say something but instead what to say. It is up to you to decide what kind of work or ideas you want to put out into the world. Artist and designer Charles Eames once said that "the first step in designing a lamp (or anything) was not to ask how it should look--but whether it should even be."[2] Certainly, a work is more effective if you feel called to do it, if you are motivated by an emotion, reacting to something, or feeling inspired or excited about an idea. Pay attention to those moments during your daily life when you experience exaggerated emotions--while watching the news, walking in your neighborhood, going grocery shopping, etc.

There are three possible approaches to guerilla art:

1. beautifying—altering your surroundings
2. questioning—using your voice, challenging the status quo
3. interacting—with the environment or people.

My good friend and artist Steve Lambert has a useful technique that he uses when teaching. It

STEVE LAMBERT'S SUPERHERO EXERCISE

By some stroke of luck you have been given a special superpower. You now have the gift of telekinesis (the ability to put your thoughts into another person's mind). You can transmit thoughts to anyone or any group of people—maybe it is everyone in your town, your state, or the world, or maybe it is just your friends. The only catch is this: you can only use the power three times.

Answer the following question: What three things do you want to put into other people's heads?

1.

2.

3.

19

has proven effective with artists of all ages. I share it with you here with his permission to help you narrow down your possibilities. It is important to take responsibility for what we put out into the world and use our power and voice with intention.

Do a brainstorming session and then pick the best ideas. What things have you been focused on in your world lately? Some things to think about:

1. Look at your environment as if you are a tourist and have never visited it. Pay close attention to the details. Look without judging.
2. Observe how people interact with the environment. Can you use their habits in an interactive piece?
3. Make note of your emotions. What gets you angry? What moves you to tears? What causes you to tune out?
4. Humor can be extremely helpful in reaching viewers, allowing them to partake in and interact with a message in a nonconfrontational way.
5. Combine/add to/alter/reinvent ideas that already exist; build on the ideas of others.
6. Use your daily life as a source for your ideas. What makes the way you perceive the world unique? How have your experiences shaped you?
7. Record ideas when they occur; keep a journal.

This book is a challenge to you to participate more fully in your immediate landscape.

By engaging our senses and responding to the tactile and sensuous qualities of the city or town in which we live we lose our feeling of separateness and enter into direct participation with our world, both physically and emotionally.

1 Emma Nicolas, "Mystery of the Arborglyphs," *Sacremento News and Review*, 22 August 2002.

2 Corita Kent and Jan Stewart, *Learning by Heart* (New York: Bantam, 1992), 41.

GOING OUT

GUERILLA ETIQUETTE

Let's start with the inevitable question of
legality. While I have some strong opinions on the
subject of what is commonly considered "vandalism"
and what is deemed "public space," the discussion
would fill another book, so I will keep it brief
here.

It is true that some of the exercises
contained in this book may be considered "illegal"
by some. On a societal level, I question why
it is perfectly acceptable that we are forced
to look at advertising on a constant basis (on
billboards, bus shelters, public restrooms, etc.),
and yet something that is a form of personal
expression (not created with the intention of
selling us something) is deemed "illegal." I do
understand that people have a problem with material
and property being "damaged" and so in my own
personal practices I try to be conscious of using
materials that are environmentally friendly and
nondestructive.

I am careful about where I choose to post
things, preferring temporary construction walls;
I rarely post art on privately owned buildings or
property. I try to create works that add to the

environment, though I am aware this is entirely subjective. And I enjoy using chalk partly because it makes me laugh to think that if I get caught I may be charged for what I would call "dusting," much like the artist known as Moose who makes paintings by drawing with soap and water on London's dirty streets.

My first foray into guerilla art was in 1993 during a class at the Ontario College of Art in Toronto, taught by conceptual artist Shirley Yanover. Yanover gave me several assignments based on making graffiti (mainly spray painting, stenciling, or improvising designs) as well as leaving art in public places to be taken. While I was aware that the practice was illegal and was extremely nervous when I went out, I had the definite feeling that I was adding something wonderful to the city I loved. Toronto developed a culture of "collectors" created by citizens who found out about our class leaving artwork out to be taken; the pieces were gone within hours. Some of them had been labored over for several days; it was both thrilling and sad to see the wall that had held them emptied so quickly. And yet I felt strangely elated knowing that my work hung somewhere, that others might be enjoying it too.

In the last few years some cities have made a choice to embrace the concept of graffiti,

hiring artists to create murals, organizing alley revitalization programs incorporating guerilla art techniques, designating graffiti walls so artists have a place to post their work, and incorporating guerilla gardening techniques for areas that need beautifying. I applaud these cities for understanding the need for its citizens to feel they have a voice and an artistic outlet and for doing something to encourage that. And I hope over time the perception of guerilla art and street art will change from one of vandalism to that of an art form no different or less valuable than anything found in a gallery.

It is up to each reader to decide what he or she is comfortable with. You may decide that you only feel at ease leaving notes in books and never venture into what might be considered more challenging work. It is not necessary that you become a guerilla artist while reading this book. It is perfectly acceptable (and encouraged) that you use this guide as a means of stimulating your own ideas for creating personal art pieces or even secret gifts for friends. Or maybe you just want to think about putting things out into the world. I hereby give you permission to not have to complete the exercises as stated. If at the very least you find the ideas interesting, that is something very worthwhile.

THINGS TO BRING

SMALL TOOLKIT

PAINT

WHEAT PASTE

BRUSHES

GLOVES

SOMETHING TO
CARRY YOUR
LEAVE-BEHINDS
IN (OR YOUR
WET STENCILS)

CLOTHING WITH
POCKETS (OPTIONAL)

CLOTHING THAT
DOESN'T STAND
OUT (DARK COLORS
AT NIGHT)

Begin by simply scouting. When you walk around your
community, keep an eye out for potential places--
temporary walls, empty planters, objects that could
be turned into characters--based on the kind of
project you want to do. Take notes.

Start small. Choose a task you are
comfortable with--maybe a quote in chalk or tiny

notes in books--to begin. You will be a little
nervous and excited. That is the fun part!

Pick a place you are familiar with, such as
the library or the sidewalk in front of your school
or office. Pretend you are supposed to be there.
Act naturally. Many people will assume you've been
commissioned.

THINGS TO LOOK OUT FOR

SECURITY
CAMERAS

SIGNS THAT
SAY "NO BILLS"
OR "POST NO
BILLS"

POLICE

Decide what time of day feels right to you. I
prefer late at night when there are fewer people
about. If passers-by start asking questions,
smile and begin a dialogue or, depending on your
personality, be vague. Politeness can be helpful.

Work quickly and change locations frequently if possible. If necessary, bring a lookout, someone to watch for authorities.

It is not always necessary for you to put your art in a place where lots of people can see it. You may want to hide your work in secret spots. This makes for a much less stressful experience. Try posting in quiet alleys, in the woods, or in places no one goes to and see how it makes you feel. One of my favorite places to write is on dead tree stumps in the woods.

:5570000 L::

Clin Code

Buying Price

Year #

Die jüng
S

Paid For _____

e # _____

Country

Amtrak is a registered service mark of the National Railroad Pas

Foreign Amount

U.S. Amount

$

HOW TO START

This section introduces various tools and techniques used by guerilla artists around the world. These techniques are simple versions using easy-to-find materials. You are encouraged to research the methods in greater detail using the resources listed in the back of this book

HOW TO MAKE A STENCIL

STENCILING IS ONE OF THE MORE POPULAR FORMS OF GUERILLA ART, DUE TO THE FACT THAT IT ALLOWS THE ARTIST TO MAKE MULTIPLE IMAGES IN A SHORT PERIOD OF TIME. IT IS RECOMMENDED THAT BEGINNERS START BY USING SIMPLE DESIGNS FOR THEIR STENCILS.

MATERIALS

CARDSTOCK
(POSTCARD WEIGHT
—MANILA FOLDERS,
SHIRTBOARD, ETC.)

PENCIL
OR
PEN

X-ACTO
KNIFE

RUBBER ROLLER

PAINT OR
GROUND-UP
CHALK

SPRAY
ADHESIVE
(OPTIONAL)

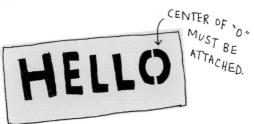
CENTER OF "O"
MUST BE
ATTACHED.
HELLO

1. START BY CHOOSING A DESIGN. IF YOU WISH, YOU CAN PRINT YOUR DESIGN DIRECTLY ONTO CARDSTOCK. FOR OUR PURPOSES THE BLACK AREAS ARE TO BE CUT OUT AND THE WHITE IS THE NEGATIVE SPACE. EACH ENCLOSED WHITE SPACE (ALSO CALLED "ISLAND") MUST BE ATTACHED TO THE STENCIL.

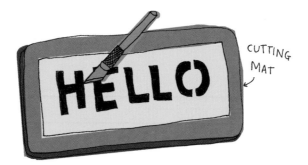

CUTTING MAT

2. PLACE SOMETHING UNDERNEATH YOUR DESIGN TO PREVENT SLIPPING; A CUTTING MAT WORKS BEST. START CUTTING OUT THE BLACK AREAS HOLDING THE KNIFE LIKE A PENCIL. BE CAREFUL, NEW BLADES ARE <u>VERY</u> SHARP. GO SLOWLY.

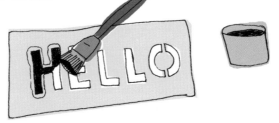

3. ONCE THE CUTTING IS DONE YOU CAN TRY MAKING A TEST PRINT. THIS GIVES YOU A CHANCE TO FIX ANY MISTAKES OR ENLARGE PARTS IF NECESSARY.

MAKE SURE THE STENCIL IS AS FLAT AS POSSIBLE AGAINST THE SPRAYING SURFACE. THIS WILL HELP TO PREVENT BLEEDING (OR WHAT IS CALLED "UNDERSPRAY"). YOU CAN ALSO USE A SPRAY ADHESIVE TO AFFIX THE STENCIL TO THE SURFACE FIRST. EXPERIMENT AT HOME BEFORE GOING OUT.

CONSIDER THAT YOUR STENCIL WILL BE WET AFTER
YOU USE IT AND YOU WILL NEED TO HAVE SOMETHING
TO CARRY IT IN.

IMPORTANT NOTE:

SPRAY PAINT IS INCREDIBLY TOXIC, BOTH TO YOU
AND TO THE ENVIRONMENT. EVEN LIMITED
EXPOSURE CAN RESULT IN PROBLEMS RANGING FROM
CANCER TO LUNG CONDITIONS TO EFFECTS ON NERVOUS
SYSTEM FUNCTION. GRAFFITI IS NOT WORTH YOUR
HEALTH. I RECOMMEND USING OTHER OPTIONS,
SUCH AS WORKING WITH A LARGE BRUSH AND
DABBING THE STENCIL WITH A WATER-BASED PAINT.
THIS TAKES A LITTLE BIT LONGER BUT YOUR HEALTH
IS WORTH IT. YOU CAN ALSO USE A ROLLER.

MANY GRAFFITI ARTISTS HAVE USED CHALK WITH
ROLLERS TO GREAT EFFECT. DIP THE ROLLER
IN THE CHALK AND SLOWLY ROLL IT OVER THE
STENCIL.

How to Make a Freezer Paper Stencil

THIS TECHNIQUE CREATES A PERMANENT WEATHER-PROOF STENCIL FOR USE ON ANY FABRIC. YOU CAN ONLY USE THE STENCIL ONCE, BUT IT IS QUITE EASY AND FUN TO MAKE SO YOU WILL WANT TO TRY IT WITH SEVERAL DESIGNS!

MATERIALS

FREEZER PAPER
(FREEZER PAPER IS WAX PAPER WITH WAX ON ONLY ONE SIDE. DO NOT TRY THIS WITH WAX PAPER.)

X-ACTO KNIFE

CUTTING MAT
(OR A SURFACE YOU CAN CUT ON)

BRUSH

PENCIL

IRON

FABRIC (WHATEVER YOU WISH TO PRINT ON)

WASHABLE FABRIC PAINT

THIS IS IT.

ONE-COLOR DESIGN (THAT YOU CAN CUT EASILY WITH THE X-ACTO)

1. CUT A PIECE OF FREEZER PAPER ROUGHLY 8½×11 INCHES. PLACE THE FREEZER PAPER ON TOP OF YOUR DESIGN, SHINY SIDE DOWN, PAPER SIDE UP. TRACE YOUR DESIGN.

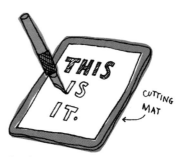

2. CUT OUT THE DESIGN USING THE MAT OR CUTTING SURFACE UNDERNEATH.

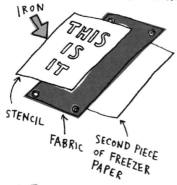

3. CUT ANOTHER PIECE OF FREEZER PAPER OF THE SAME SIZE. PLACE THIS UNDERNEATH THE FABRIC YOU ARE STENCILING ONTO, SHINY SIDE <u>UP</u>. PLACE YOUR CUT-OUT STENCIL ON TOP OF THE FABRIC, SHINY SIDE <u>DOWN</u>. USING A DRY SETTING, IRON ON.

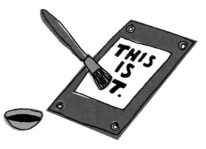

4. DAB YOUR STENCIL WITH THE FABRIC PAINT. LET DRY. PEEL OFF STENCIL. HEAT SET ACCORDING TO FABRIC PAINT INSTRUCTIONS.

HOW TO MAKE STAMPS

YOU CAN MAKE STAMPS USING A VARIETY OF MATERIALS.
FOR SIMPLE SHAPES POTATO STAMPS ARE A QUICK AND
EASY OPTION, BUT THEY HAVE A LIMITED LIFE SPAN
(YOU MUST MAKE ALL YOUR PRINTS IN ONE SITTING).
IF YOU WANT A MORE DETAILED STAMP, INNER TUBES,
RUBBER ERASERS, AND STYROFOAM FOOD PACKAGES WILL
GIVE YOU CRISP LINES AND ALLOW YOU TO DO MULTIPLE
PRINTINGS.

POTATO PRINTS

1. CUT A RAW POTATO
IN HALF LENGTHWISE.

2. CARVE YOUR DESIGN
USING A SHARP
KNIFE.

3. INK WITH A
STAMP PAD
OR PAINT. PR

INNER TUBE

1. CUT DESIRED SHAPE
OUT OF A PIECE OF INNER
TUBE (THE PART YOU WANT
PRINTED).

2. GLUE THE SHAPE
ONTO A FIRM SURFACE
(WOOD OR FIRM
CARD BOARD).

3. INK WITH
STAMP PAD.
PRINT.

STYROFOAM STAMPS

CUT OUT A FLAT SQUARE PIECE FROM A STYROFOAM FOOD TRAY (THE KIND USED FOR PACKING MEAT OR PRODUCE).

2. USING A BALL-POINT PEN, DRAW A DESIGN ONTO THE STYROFOAM. USE PRESSURE. KEEP IN MIND THAT THE PLACES YOU DRAW WILL BE THE PARTS THAT DON'T PRINT (LOW SPOTS).

3. YOU CAN INK THE STAMP USING A STAMP PAD OR WITH AN INK BRAYER. FOR A MORE DURABLE STAMP, GLUE THE STYROFOAM TO A PIECE OF WOOD.

ERASER STAMPS
MATERIALS

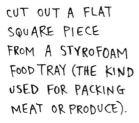
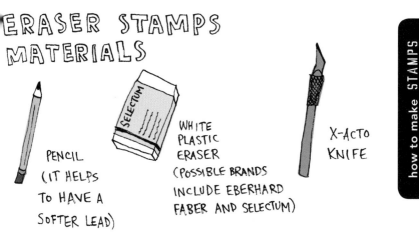

PENCIL (IT HELPS TO HAVE A SOFTER LEAD)

WHITE PLASTIC ERASER (POSSIBLE BRANDS INCLUDE EBERHARD FABER AND SELECTUM)

X-ACTO KNIFE

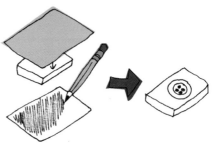

1. USING A PENCIL, TRACE YOUR DESIGN ONTO A PIECE OF PAPER MAKING SURE THE IMAGE IS REVERSED IF NECESSARY. TURN OVER THE TRACING AND PLACE IT FACE DOWN ON THE ERASER.

2. USING THE PENCIL, SKETCH VIGOROUSLY OVER THE BACK OF THE DESIGN TO TRANSFER IT ONTO THE ERASER. TRY NOT TO MOVE THE PAPER DURING THE TRANSFER OR YOUR LINES WILL BE BLURRY. IF YOU MAKE A MISTAKE, YOU CAN ERASE IT USING ANOTHER ERASER.

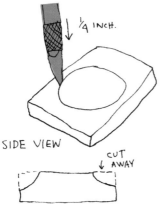

¼ INCH.

SIDE VIEW

CUT AWAY

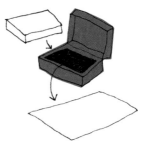

3. WITH THE X-ACTO, SLOWLY AND CAREFULLY CARVE AROUND THE DESIGN GOING DOWN ABOUT ¼ INCH DEEP. THE FIRST INCISION SHOULD BE STRAIGHT DOWN. CUT AWAY THE EXCESS AT A SLIGHT ANGLE.

4. INK USING A STAMP PAD AND PRESS DOWN ONTO A STICKER OR A PIECE OF PAPER.

MONOPRINT

THIS METHOD IS A QUICK AND EASY WAY OF
MAKING ONE-OFF PRINTS FOR POSTERS OR ART
LEAVE-BEHINDS. IT IS MORE EXPERIMENTAL
THAN THE PREVIOUS PRINTING TECHNIQUES
AND DOES NOT ALLOW FOR A LOT OF CONTROL
OVER THE FINAL IMAGE.

MATERIALS

A PIECE OF GLASS
(APPROX. 10-12 INCHES
SQUARE, POSSIBLY FROM
AN OLD PICTURE FRAME)

BLOCK PRINTING
INK (OR AN OIL-
BASED PAINT)

BRAYER
(ROLLER, AVAILABLE
IN ART SUPPLY
STORES)

BRUSHES
(YOU CAN USE EITHER
END AS A TOOL)

PLASTIC CONTAINER
(OR DISH)

PAPER TO
PRINT ONTO

39

1. SQUEEZE A SMALL AMOUNT (ABOUT AN INCH) OF INK INTO THE PLASTIC CONTAINER. DIP YOUR BRUSH INTO THE INK AND BEGIN TO DRAW YOUR DESIGN ONTO THE GLASS. IT HELPS TO USE A LOT OF INK. KEEP IN MIND THAT THE IMAGE WILL BE REVERSED WHEN PRINTED.

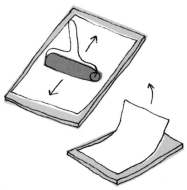

2. WHEN THE DESIGN IS FINISHED, PLACE A PIECE OF PAPER ON TOP OF IT AND ROLL (RUB) WITH THE BRAYER. (THE LINES WILL SPREAD SLIGHTLY WITH THE RUBBING.) PEEL THE PAPER OFF OF THE GLASS AND PLACE SOMEWHERE TO DRY.

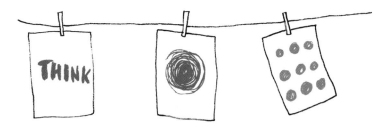

THINK

HOW TO MAKE STICKERS

WHY MAKE STICKERS IN A TIME WHEN THERE ARE MANY PREMADE VERSIONS ON THE MARKET THAT PROBABLY WORK BETTER THAN ANYTHING YOU COULD MAKE AT HOME USING SIMPLE HOUSEHOLD INGREDIENTS?

THE ANSWER TO THIS IS TWO FOLD: 1) BECAUSE BY MAKING YOUR OWN YOU CAN USE ANY SHAPE, SIZE, OR PAPER FORMAT YOU WISH, AND 2) BECAUSE MAYBE YOU ARE THE TYPE OF PERSON WHO LIKES TO MAKE THINGS FROM SCRATCH AND ENJOYS KNOWING THE ENTIRE PROCESS FROM START TO FINISH. (OR PERHAPS YOU ARE JUST TIRED OF SUPPORTING LARGE CORPORATE OFFICE SUPPLY STORES.) WHATEVER THE REASON, HERE ARE SOME VERSIONS FOR YOU TO EXPERIMENT WITH AS WELL AS VARIATIONS USING PREMADE SOURCES.

LICK AND STICK RECIPE
MATERIALS

SCISSORS

½ TSP SUGAR

1 TBSP COLD WATER

BRUSH

WRITING / DRAWING UTENSILS
(OR PRINTMAKING TECHNIQUES)

GELATIN

1 PACKAGE UNFLAVORED GELATIN (¼ OZ.)

3 TBSP HOT WATER

SEVERAL SHEETS OF PLAIN PAPER

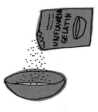

1. CREATE YOUR DESIGNS ON THE FRONT OF THE SHEET OF PAPER USING WHATEVER METHOD YOU LIKE—INK DRAWINGS, POTATO PRINT, ERASER STAMP, STENCIL, OR PHOTOCOPY.

2. SPRINKLE GELATIN INTO THE COLD WATER. LET IT SOFTEN FOR FIVE MINUTES.

3. POUR IN HOT WATER AND STIR UNTIL DISSOLVED. ADD SUGAR AND STIR WELL.

4. USING A BRUSH, PAINT THE BACK OF THE PAPER WITH THE GELATIN SOLUTION. (IT WORKS BEST IF YOU LAY IT ON THICK.) LET DRY.

5. FLATTEN SHEET UNDER A HEAVY BOOK. CUT OUT STICKERS.

6. LICK AND STICK.

WET AND STICK (NON-LICKING) RECIPE

MATERIALS

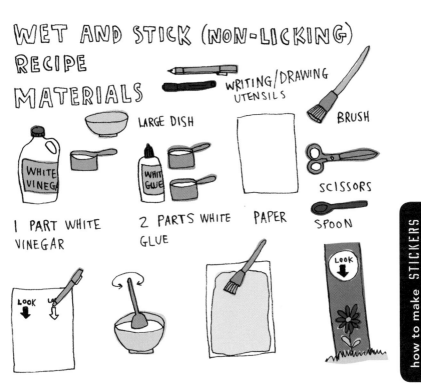

WRITING/DRAWING UTENSILS

LARGE DISH

BRUSH

WHITE VINEGAR

WHITE GLUE

SCISSORS

PAPER

SPOON

1 PART WHITE VINEGAR

2 PARTS WHITE GLUE

LOOK ↓

1. CREATE YOUR DESIGN ON THE FRONT OF THE PAPER.

2. MIX GLUE AND VINEGAR REALLY WELL.

3. USING THE BRUSH, PAINT THE BACK OF THE STICKERS WITH GLUE SOLUTION. LET DRY.

4. CUT OUT. WET AND STICK.

 FOR ADDED WEATHER PROOFING PUT CLEAR PACKING TAPE ON THE FRONT OF THE STICKERS BEFORE CUTTING THEM OUT.

MAKE YOUR OWN 'STAMPS' USING A SEWING MACHINE TO PERFORATE THE PAPER. REMOVE THE THREAD FROM THE MACHINE AND SEW A GRID ONTO YOUR SHEET OF PAPER.

43

NOTE: THESE ARE NOT THE MOST DURABLE STICKERS, BUT THEY ARE DEFINITELY EASY TO USE AND MAKE. YOU CAN TRY WEATHERPROOFING WITH A LAYER OF PACKING TAPE OR SOME FIXATIVE (MATTE MEDIUM). THE SOLUTION SHOULD BE USED RIGHT AWAY OR IT SOLIDIFIES (THAT IS, TURNS INTO JELL-O).

OTHER STICKER MAKING METHODS

YOU CAN FIND PREMADE FREE STICKERS OF EXCELLENT QUALITY AT THE POST OFFICE. THE CATCH IS YOU WILL HAVE TO ALTER THE DESIGN AS NEEDED. ONE WAY TO DO THIS IS TO PRINT ON TOP OF AN EXISTING STICKER, USING SIMPLE PRINTMAKING TECHNIQUES SUCH AS LINOCUT, POTATO PRINTING, OR STENCILING. YOU CAN ALSO JUST DO SOME DRAWINGS ON TOP.

YOU CAN PURCHASE PRINTER-READY STICKERS AT ANY OFFICE SUPPLY STORE AND PRINT YOUR DESIGNS OFF IN LARGE BATCHES, THOUGH YOU WILL NEED TO WEATHERPROOF YOUR STICKERS IF USING AN INK-JET PRINTER. OPTIONS FOR THIS INCLUDE ACRYLIC MEDIUM, WHICH COMES IN SPRAY OR PAINT FORM, CLEAR ENAMEL, OR PACKING TAPE.

QUICKEST STICKERS IN THE WORLD
MATERIALS: POST-IT NOTES, A PEN
1. DO A DRAWING. 2. STICK IT UP.

HOW TO MAKE A SEED BOMB

SEED BOMBS (OR BALLS) ARE A WAY TO ADD GREENERY AND LIFE (AND ALSO FOOD) TO PLACES THAT ARE NEGLECTED OR RUNDOWN. THEY WORK IN ANY PLACE THAT HAS A BIT OF DIRT AND ACCESS TO SUN AND RAIN. THIS VERSION WAS INSPIRED BY THE AMAZING MASANOBU FUKUOKA, WHOSE WORK I HIGHLY RECOMMEND YOU RESEARCH. EASY TO MAKE, SEED BOMBS DO NOT NEED TO BE BURIED OR WATERED (THAT IS THEIR GENIUS!) — THE SEEDS WILL SELF-GERMINATE WHEN THE RIGHT CONDITIONS OCCUR. THEY CAN BE THROWN INTO LANDFILL SITES OR UNUSED EMPTY LOTS (MAKE SURE THE LAND IS NOT TOXIC IF YOU WANT TO GROW FOOD). EVEN A CRACK IN THE SIDEWALK WILL DO. LEAVE LETTUCE BOMBS IN CITY PLANTERS! PLANT FLOWERS ALONG THE CURB! IT'S EASY TO TRANSFORM YOUR WORLD WITH A FEW SIMPLE SEEDS.

MATERIALS

MIXED SEEDS
(ALWAYS USE NATIVE SEEDS. NON-NATIVE SEEDS CAN BE HARMFUL TO THE ECO-SYSTEM.)

COMPOST

POWDERED RED OR BROWN CLAY
(YOU CAN ORDER TERRA-COTTA CLAY FROM CERAMIC SUPPLY COMPANIES. IF YOU LIVE BY A CREEK, LOOK FOR DRIED PATCHES OF IT.)

WATER

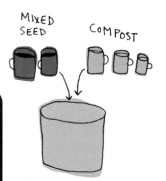

MIXED SEED COMPOST

1. COMBINE 2 PARTS MIXED SEEDS WITH 3 PARTS COMPOST.

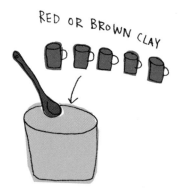

RED OR BROWN CLAY

2. STIR IN 5 PARTS POWDERED RED OR BROWN CLAY.

3. MOISTEN WITH WATER UNTIL MIXTURE IS DAMP ENOUGH TO MOLD INTO BALLS.

4. PINCH OFF A PENNY-SIZED PIECE OF THE CLAY MIXTURE AND ROLL IT BETWEEN THE PALMS OF YOUR HANDS UNTIL IT FORMS A TIGHT BALL (1 INCH IN DIAMETER).

5. SET THE BALLS ON NEWSPAPER AND ALLOW TO DRY FOR 24-48 HOURS. STORE IN A COOL DRY PLACE UNTIL READY TO SOW.

HOW TO MAKE WHEAT PASTE

WHEAT PASTE IS ONE OF THE MOST ENVIRONMENTALLY FRIENDLY POSTER ADHESIVES. IT BREAKS DOWN EVENTUALLY AND IS EASIER TO REMOVE THAN TAPE OR STAPLES. PLUS IT IS CHEAP AND EASY TO MAKE! HERE ARE TWO VERSIONS: HEATED AND NO-HEAT. THE HEATED TYPE MAKES FOR A MUCH SMOOTHER AND DURABLE PASTE AND IS THE RECOMMENDED METHOD, BUT I OFFER THE NO-HEAT RECIPE IN CASE YOU HAVE NO ACCESS TO A STOVE.

MATERIALS

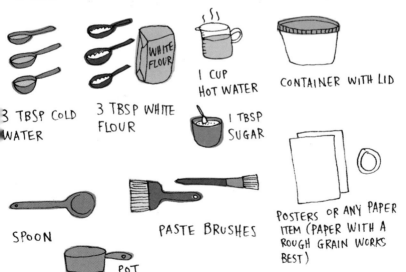

3 TBSP COLD WATER

3 TBSP WHITE FLOUR

1 CUP HOT WATER

1 TBSP SUGAR

CONTAINER WITH LID

SPOON

PASTE BRUSHES

POT

POSTERS OR ANY PAPER ITEM (PAPER WITH A ROUGH GRAIN WORKS BEST)

47

HEATED RECIPE

1. PUT WATER IN KETTLE TO BOIL. MAKE A MIXTURE OF THE FLOUR AND COLD WATER TO MAKE A SMOOTH PASTE. (ADD A BIT MORE WATER IF NEEDED.)

2. MEASURE HOT WATER INTO A POT OVER MEDIUM HEAT. SLOWLY POUR THE COLD MIXTURE IN WITH THE HOT WATER, STIRRING CONSTANTLY. BRING TO A BOIL UNTIL PASTE THICKENS. TURN OFF HEAT.

SUGAR

3. ADD A TABLESPOON OF SUGAR AND MIX WELL. ALLOW TO COOL. COVER AND KEEP REFRIGERATED UNTIL USE.

4. TO PASTE, PAINT THE SURFACE WITH A LAYER OF PASTE. SMOOTH YOUR POSTER ON TOP OF IT, MAKING SURE THE CORNERS ARE STICKING. BRUSH A THIN LAYER OF PASTE OVER YOUR POSTER TO MAKE IT MORE WEATHERPROOF.

* YOU CAN ALSO ADD A BIT OF WHITE GLUE (PVA) ONCE THE
 PASTE HAS COOLED FOR ADDED DURABILITY.

NO-HEAT RECIPE
MATERIALS

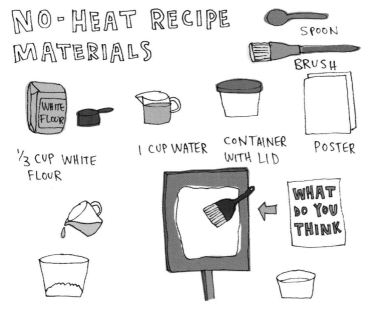

SPOON

BRUSH

WHITE FLOUR

1/3 CUP WHITE
FLOUR

I CUP WATER

CONTAINER
WITH LID

POSTER

WHAT
DO YOU
THINK

1. POUR FLOUR INTO
CONTAINER AND START
ADDING WATER. STIR
WELL UNTIL MIXTURE TAKES
ON A GLUE-LIKE CONSISTENCY.
TEST FOR ITS SPREADING
ABILITY. COVER CONTAINER
WITH LID TO PREVENT FROM
DRYING OUT.

2. PAINT THE SURFACE
WITH A LAYER OF PASTE.
SMOOTH YOUR POSTER
ON TOP OF IT, MAKING
SURE THE CORNERS ARE
STICKING. BRUSH A THIN
LAYER OF PASTE OVER YOUR
POSTER FOR WEATHERPROOFING.

EXERCISES

This section has a variety of guerilla art exercises of varying difficulty. I have included a wide range of media from chalking to dance, to sound, to movement, in an effort to promote the idea that there are no limits to what guerilla art is. Push the ideas as far as you can; alter them as you try them out. Then develop your own methods and techniques. Guerilla art has a long history of sharing and building on the ideas of others!

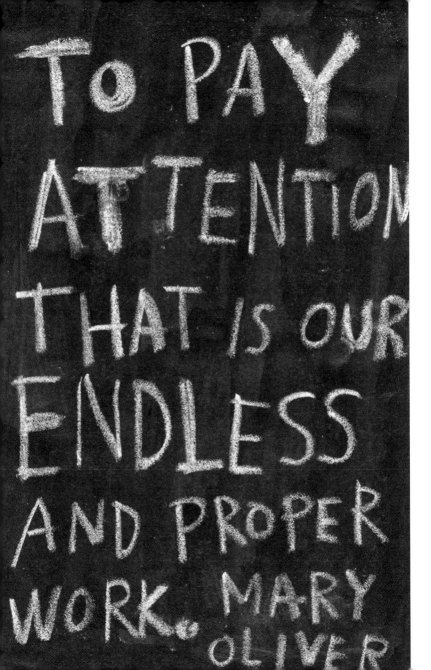

CHALK QUOTES

MATERIALS: NOTEBOOK
PEN
CHALK

1. Start by collecting some quotes that you really respond to. Shorter ones work best and use less chalk.

2. Scout for a location you feel good about—in front of the post office, the library, on an urban street.

3. Pick a time to go out (read section on "going out" on page 22). Start chalking. You will find that writing on sidewalks uses up the chalk rather quickly. Have a good supply on hand (read: bring more than you think you need).

You may want to visit the location at another time and watch people responding to the quotes. This is one of the fun things about chalking; no one will know you were the artist.

GUERILLA GARDENING

MATERIALS: TROWEL
SEEDS
WATERING CONTAINER
SOIL (OPTIONAL)

1. Take a walk around any neighborhood. Tune into places where you might be able to scatter seeds. Look for sidewalk cracks, empty planters, ditches, ugly green spaces, spaces next to ugly buildings, anywhere that might benefit from some sprucing up. (Pay attention to sun and soil. You may have to add a bit of soil to make the conditions more agreeable.)

2. Plant seeds in scouted areas.

3. Watch them grow. Occasional maintenance (watering) may be helpful. Feel good knowing you have made your area more beautiful. You might also want to experiment with planting easy-to-grow food, such as lettuce, beans, and herbs.

ALTERNATE VERSION:
1. Create seed bombs (page 45).

2. Throw them into fenced industrial areas or landfill sites.

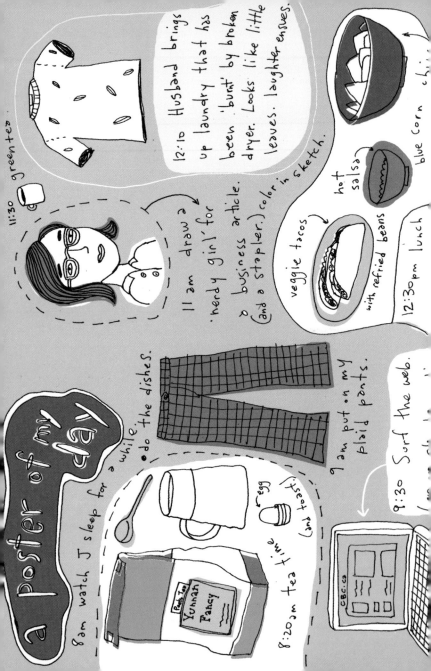

POSTER OF YOUR DAY

MATERIALS: **8 1/2 X 11-INCH SHEET OF PAPER**
UTENSILS (PENS, MARKERS)
PHOTOGRAPHS (OPTIONAL)
PHOTOCOPIER
PASTE
BRUSHES

1. On a piece of paper draw, write, or attach photos documenting an average day in your life. (Alternately it could be a day in the life of a fictional character.)

2. Photocopy your poster as many times as you like.

3. Post your copies in a public place.

ALTERNATE VERSION:
 Write the story of your life or copy a few lines from your journal either in chalk or on paper. Post these anonymously. Do regular installments.

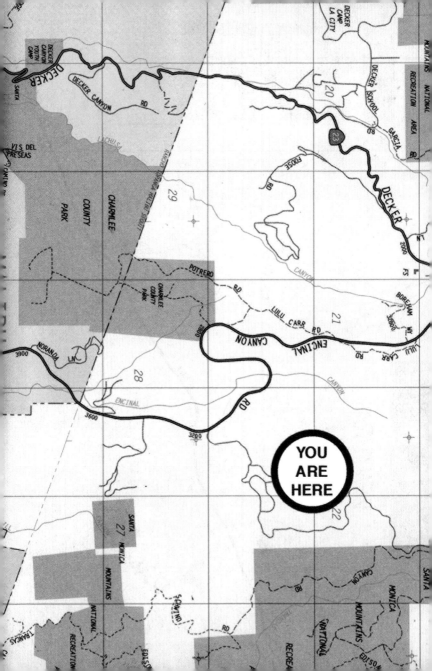

MAP OF THE AREA

MATERIALS: NOTEBOOK
MAP
PEN
GLUE OR TAPE
SCISSORS

1. Either draw a map of the area you wish to post in or use an existing one.

2. Cut out a "you are here" marker (page 125). Glue it onto the spot where you will be leaving the map. Add your favorite points of interest to the map—nice place to sit, favorite tree, good burritos, etc.

3. Go to your location and hang the map. You may use the wheat paste recipe (page 47) or packing tape to affix it. Hang several of these at various points in the neighborhood.

YOU LOOK REALLY GOOD TODAY.

HIDDEN FORTUNES

MATERIALS: **8 1/2 X 11-INCH** SHEET OF PAPER
PEN
SCISSORS

1. Cut the paper into little slips approximately 1 by 3 inches.

2. Write a fortune or affirmation on each of the slips. Some ideas include, "You look really good today," "Someone is thinking about you right now," and "You are a star."

3. Fold these fortunes and drop them randomly wherever you go (post office, work, in stores, in books, in planters). Feel good knowing that someone will find them in the near future.

NOTICE

The crooked tree
to your right.

NOTICE

The sound your
feet make on the
pavement.

NOTICE

Your inhalation
and exhalation.

NOTICE

The third-floor
window of the
building to your
right. There are
red geraniums.

LITTLE NOTICES

MATERIALS: PAPER
PEN
SCISSORS
GLUE OR TAPE

1. Wander around your neighborhood and look for things of beauty, things of interest, or things that are unique (for example, found faces in or on human-made things such as plumbing).

2. Write about these things on a piece of paper. "Notice the single tree to your right," or "Notice the purple curtains on the third floor."

3. Post the notices for people to read.

Please
take
one.

This coupon entitles the user to:
One free day to do anything you want.
What will it be?

This coupon entitles the user to:
One free day to do anything you want.
What will it be?

This coupon entitles the user to:
One free day to do anything you want.
What will it be?

This coupon entitles the user to:
One free day to do anything you want.
What will it be?

This coupon entitles the user to:
One free day to do anything you want.
What will it be?

This coupon entitles the user to:
One free day to do anything you want.
What will it be?

COUPON POSTER

MATERIALS: PAPER
PEN
SCISSORS
GLUE OR TAPE

1. Create a coupon poster following the model pictured here.

2. On the coupons under "This coupon entitles the user to..." fill in your own ideas. For example, "One free day to do anything you want. What will it be?" or "Unlimited deep breaths for the rest of the day."

3. Hang the poster in a location where other coupon posters are found (office bulletin board, a sign post, at school).

Dear _____,

I wanted to send you a note to tell you
I've been admiring you from afar. I like
the way you move about the world with such
_____ and _____. I know it may
come as a surprise to you that you have an
admirer, but I assure you it is with a
respectful tone that I send this note.

You see, I am not looking for anything in
return. My motivation is only to spread a
little _____ about the world. I hope
that you will accept this compliment with
_____. And if you feel moved to do
so, pass it on to someone you admire or
someone you would like to share a kind
thought with.

Sincerely yours,
your admirer

LOVE LETTER

MATERIALS: PAPER
PEN
ENVELOPE

1. Write a love letter that you would like to receive.

2. Leave it in a public place.

ALTERNATE VERSION:
1. Write a love letter to someone you admire, telling them all of the things you like about them.

2. Send it to them anonymously.

PUBLIC CHALKBOARD

MATERIALS: CHALKBOARD PAINT (IN GREEN OR BLACK)
BRUSH
CHALK

1. Find a place where you would like to "install" a chalkboard. (This is an appropriate exercise for those invasive bathroom stall advertisements. Turn them into interactive art pieces.)

2. Paint the desired surface with chalkboard paint. (If you choose an existing ad you may want to cover just the type or make a thought bubble coming from a figure.)

3. Leave chalk for people to share their own thoughts.

ALTERNATE VERSIONS:
Leave a bucket of chalk beside a chalk drawing.

Leave a notebook in a public space, asking people to draw or write in it and pass it on.

Hang up a poster with a pen attached, asking people to leave a thought.

This book now belongs to you.

It is a book that I (the previous owner) enjoyed greatly and so I would like to pass it on. Please read it (if you are drawn to do so). If not you may just leave it where you found it or pass it on to someone else.

Vita sine.

date: _ _ _ _ _ _ _ _ _ _ _ _ _ _ _ _ _ _

BOOK LEAVE-BEHINDS

MATERIALS: **PAPER** (SEE TEMPLATE ON PAGE 127)
PEN
GLUE

1. Cut out the bookplates on page 127.

2. Adhere them to a book you no longer want. If you
 would like to track the book you can write your email
 address on the bookplate.

3. Leave the book in a public place.

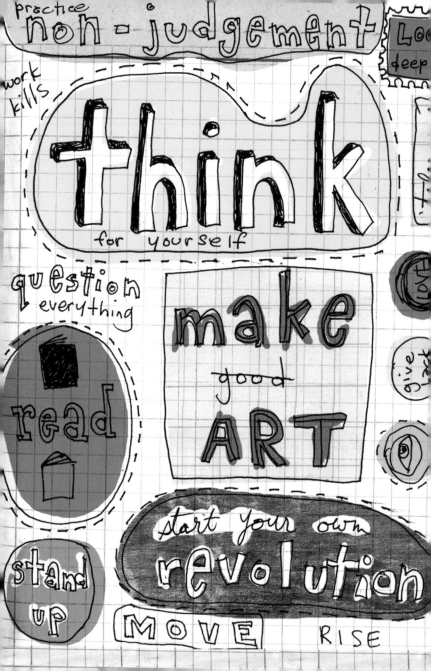

SLOGAN STICKERS

MATERIALS: BLANK STICKERS (PAGE 123)
PEN AND/OR MARKERS

1. Come up with a series of slogans based on your own
 way of seeing the world. You may want to use single
 words, such as think, dream, revolt, sing, and yell.

2. Write the slogans on the blank stickers.

3. Follow the instructions on "How to Make Stickers"
 on page 41.

4. Place the stickers in a variety of public places.

ALTERNATE VERSION:
 Label things that exist in the environment, such as a
 tree, sidewalk, mailbox, lamp, or fence.

FOUND PHOTOS

MATERIALS: POLAROID CAMERA
PEN
TAPE

1. Go out into your neighborhood and take some photos of things you are drawn to.

2. Write the date on the photos.

3. Post them close to where you took them.

ALTERNATE VERSION:
Take a photo of yourself in various locations.
Post the photos close to where you took them.

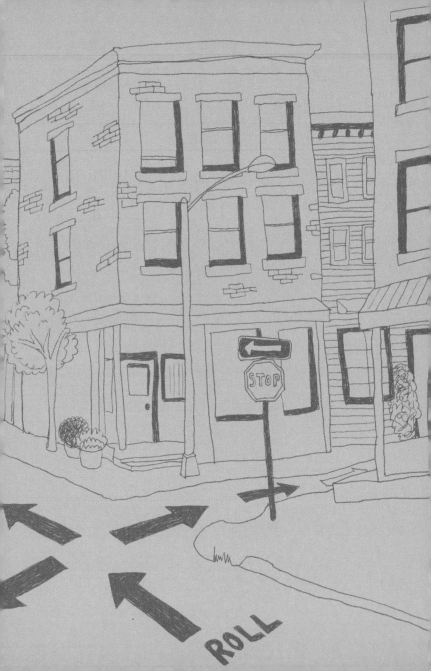

DICEWALK

MATERIALS: **DIE TEMPLATE** (PAGE 129)
GLUE

1. Cut out the die template on page 129 and glue together according to instructions.

2. Go to any location you wish. Roll the die every time you come to an intersection, side street, or byway. The solid line always indicates the bottom (or the position of your body).

3. Head in the direction that is closest to the direction indicated on the die.

RULES OF PLAY

You may only reverse direction if a) you come to a dead end or b) you find yourself in a situation where you feel unsafe or uncomfortable. For unusual intersections, decide on fair conditions of play before rolling the die.

No looping: you may not walk in the same direction in the same place more than once. When you come to an intersection you have already been to during your dicewalk, you will not consider the path previously taken to be an option. You may go the opposite way on the same path once.

Resource: This exercise was adapted from a version designed by the San Francisco artist Larnie Fox. You may wish to try his version, which uses a regular die. Visit http://www.infoflow.com/larnie/dicewalk/rules.pdf.

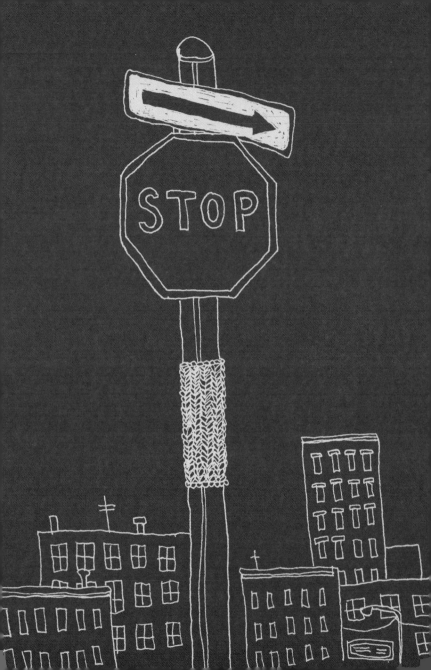

KNITTED TAGS

MATERIALS: **KNITTING NEEDLES** (ANY SIZE YOU WISH)
WOOL YARN (PREFERABLY OF DIFFERENT COLORS)
MEASURING TAPE
LARGE NEEDLE TO SEW ENDS TOGETHER

1. Measure length or diameter of the item you want to tag. In this example I used a street sign and made the "tag" five inches wide.

2. Cast on enough stitches for the width you desire. Knit several rows until you reach the necessary length, changing colors as desired. Crochet can also be used.

3. Sew the knitted piece onto the object, binding the ends using the basting stitch.

ALTERNATE VERSIONS:
Knitted garlands for trees or fences—knit a long thin piece using many colors of wool.

Knitted ornaments hung from trees.

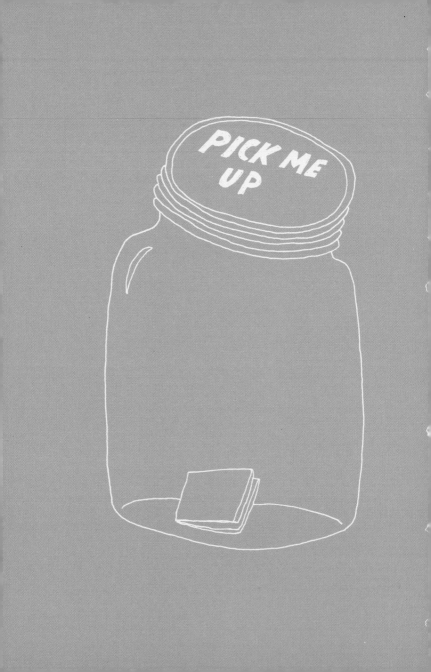

THE UNEXPECTED OBJECT

MATERIALS: JAR
FOUND OBJECT
PAPER
PEN

1. Get a jar and write on the lid, "Pick me up."

2. Put something of interest inside it—a note, a found object, etc.

3. Leave it on a park bench.

ALTERNATE VERSIONS (THE UNEXPECTED OBJECT):
Put tags on objects that say "a gift for you."

Leave hand-written or typed notes in the pockets of pants for sale in a store.

ALTERNATE VERSIONS (THE EXPECTED OBJECT):
Paint stones with a message and blend them well into a landscaped setting.

Put one of your handmade books onto a library display.

Create a poster that looks like a street sign (but with an alternate message) and post it on a busy street.

GUERILLA MAIL

MATERIALS: CARDSTOCK
ART SUPPLIES
POSTAGE STAMP

1. Start an anonymous mail postcard chain with friends,
 with a note on the back explaining the concept:

 Dear friend,
 You are invited to take this postcard and alter/add
 to it in some way. Use whatever method you would
 like; it is up to you. Do not worry about covering
 up the existing artwork. Do not obscure this
 note. When you are finished, mail the postcard to
 someone else.

2. These ideas could inspire your postcard design:
 quotes or poetry, drawings or photos, a section for
 the recipient to fill in, random thoughts, collage.

INSTALLATIONS

MATERIALS: PAPER
TAPE
STICKERS
POST-IT NOTES

Using Post-it notes, create a trail of words (or quotes). You can also fill a wall with your Post-it stickers.

ALTERNATE VERSIONS:

Spell a word or do a simple drawing in public.

With the help of a partner outline your silhouette.

Using plain circle stickers, make a polka-dot wall.

OBOS

JAPANESE TERM FOR A
PILE OF ROCKS THAT
COMMUNICATES A SIMPLE
MESSAGE TO PASSERSBY.

FOUND IN THE ENVIRONMENT

MATERIALS: YOUR ENVIRONMENT

1. Make a piece using things that already exist in the environment; for example, arrange discarded colored plastic lids, decorate discarded bike frames, or make a pattern out of pebbles.

2. Decorate a chain-link fence using paper, used cups, leaves, twigs, etc. Spell words. One of my favorite experiences was walking through a park and coming across a tree in California that had been spontaneously decorated by small children. It was full of colored ornaments, feathers, painted twigs, and painted eggs.

3. Create characters using things found on the street.

4. Experiment with different drawing methods: drawing in dirt (or dust), using soap and water to draw on a dirty wall or sidewalk, writing in snow with food coloring or tempera paint, using stones, adding color with plastic soda lids.

TO WHOEVER FINDS THIS CARD...

THIS CARD IS A WORK OF ART.

YOU HAVE THREE CHOICES:

1. LEAVE IT WHERE YOU FOUND IT FOR SOMEONE ELSE TO FIND.

2. WRITE A NOTE, DO A DRAWING, DEFACE IT, ALTER IT (NOTE THE DATE AND WHERE YOU FOUND THE CARD).

3. GIVE THE CARD TO SOMEONE ELSE.

POSTCARD PROJECT

MATERIALS: POSTCARD TEMPLATE (PAGE 131)
POSTAGE

1. Photocopy the template on page 131 onto cardstock.

2. Affix postage.

3. Leave postcard in random places for people to find.

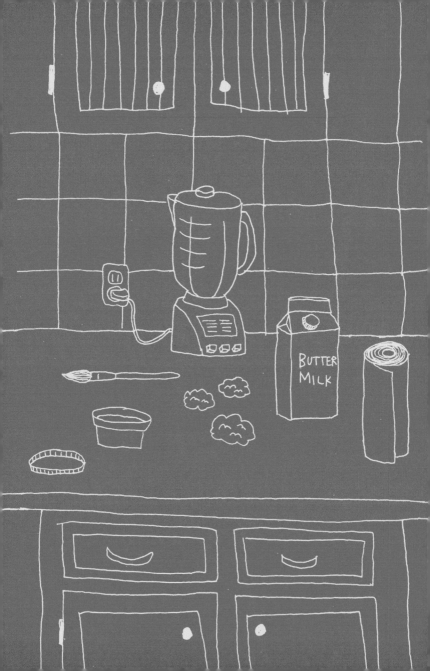

MOSS GRAFFITI

MATERIALS: 12 OZ. OF BUTTERMILK
SEVERAL CLUMPS GARDEN MOSS
PLASTIC CONTAINER (WITH LID)
BLENDER
PAINTBRUSH

This recipe makes enough to create several small pieces or one large piece of graffiti.

1. Gather several clumps of moss and crumble them into a blender. Moss can usually be found in moist, shady places.

2. Add the buttermilk and blend just long enough to create a smooth, creamy consistency. Now pour the mixture into a plastic container.

3. Find a suitable damp and shady wall onto which you can apply your moss milkshake. Paint your chosen design onto the wall (either freehand or using a stencil). If possible return to the area over the following weeks to ensure that the mixture is kept moist. Soon the bits of blended moss should begin to grow into a rooted plant, maintaining your chosen design before eventually colonizing the whole area.

Resource: This idea was shared with me by Helen Nodding of storiesfromspace.co.uk. She introduces it as an "old favorite of gardeners." In its new connotation it provides an excellent nontoxic alternative to spray paint. Helen recently received a recipe that improved on her own methods from a reader named Jeff Watson.

TODAY ONLY
FREE LESSONS
TOPIC...
HOW TO START
A CONVERSATION
WITH STRANGERS.
(FIRST COME, FIRST SERVE)

GUERILLA ACTIONS

1. Public gift: set up a table in a public space. Offer a service for free. Choose something you are good at: free "how to start a conversation with a stranger" lesson, free "write backwards" lesson, etc.

2. Public living: consider various ways in which you can do your daily tasks (watching a movie, eating dinner, napping, etc.) in interesting public spaces.

3. Public dancing: put on headphones, play music you really enjoy, go out to a public space, and dance.

4. Public workstation: set up a portable office in a public location with a sign saying, "Do not disturb, work in progress."

Resources: Steve Lambert, Rebar, Mike Schwartz, and Jeff Pitcher

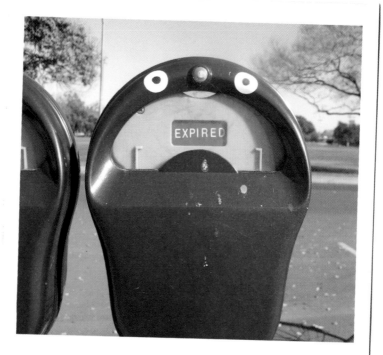

MAKING "FRIENDS"

MATERIALS: PAPER
PEN

1. Draw eye circles on a piece of paper.

2. Paint back of page with wheat paste.

3. Cut out eye circles.

4. Place them onto inanimate objects (fire hydrants, parking meters, door handles, etc.) in public places. You can also use the additional parts on page 133.

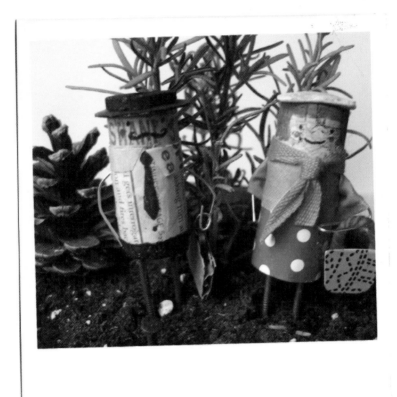

MINIATURE ENVIRONMENTS

MATERIALS: CUT-OUT PAPER WITH
LITTLE STANDS (TAPE
THEM DOWN SO THE WIND DOESN'T
BLOW THEM AWAY)
PAPER CLIPS
CORKS
WIRE

SHELLS
SPOOLS
ERASERS
PUSHPINS
BUTTONS
BOTTLE CAPS

1. Create a tiny scene and install it in an unexpected place.

2. Possible spaces might include cracks in walls or sidewalks, parts of staircases that are not used, any platformlike surface, ATM kiosks, and tree branches. Pick a space that simulates or helps recreate the environment you want to create.

IDEAS FOR SCENES:
Recreate your favorite room. Make a cityscape with tiny buildings, streets, and people. (Maybe it is a space for ants.) Make a landscape with trees, bushes, water. Recreate people involved in some kind of activity.

ALTERNATE VERSION:
Hide the scene and direct people to it using an arrow.

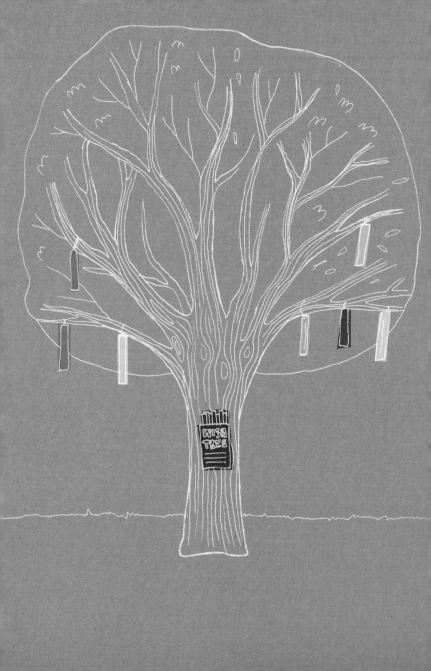

WISH TREE

ENVELOPE
PAPER OR FABRIC
SCISSORS
PEN
TAPE
STRING

1. Create an envelope or use an existing one.

2. Cut out blank tags and punch a hole near one end of each tag. Tie 5-inch pieces of string to the holes. Place tags in envelope.

3. Affix envelope and pen to a tree or somewhere nearby. Write some of your own wishes on a few tags and hang them there to encourage others. You can do this exercise using a tree you find in public or if you have a tree in your front yard that passers-by have access to.

ALTERNATE VERSION:
Instead of tags, use colored ribbons approximately 10 inches long. This makes for a visually beautiful tree when full.

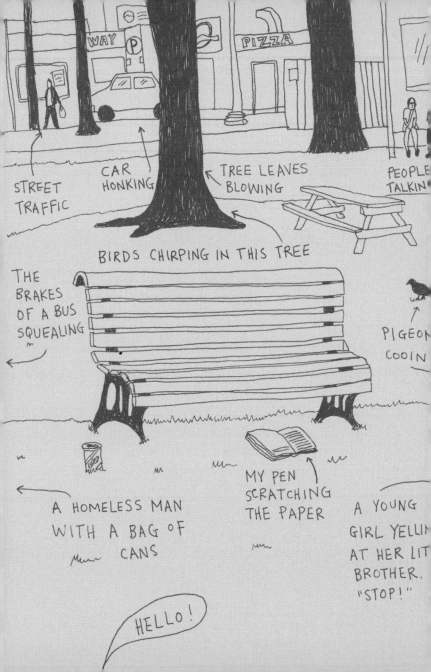

SOUND COLLAGE

MATERIALS: PAPER OR CARDSTOCK
PEN OR PENCIL
WHEAT PASTE

1. Go to a location in a public setting. It could be a park, a café, your school, etc.

2. Close your eyes. Listen closely to all of the sounds you hear. Make a list of the sounds. Make the list as detailed as possible.

3. Post your list somewhere nearby.

ADVANCED ALTERNATE VERSION:
Record a sound "landscape" and publish it on a wireless network, using the Tactical Soundgarden Toolkit. Instructions found at http://www.tacticalsoundgarden.net.

Resource: Pauline Oliveros, Deep Listening

1. CUT OUT THE PORTABLE IDEA DISPENSER ALONG THE RED LINES.

GLUE HERE

the portable idea dispenser

2. FOLD ALONG THE DOTTED LINES TO FORM A BOX SHAPE ADD GLUE AND SEAL, LEAVING DISPENSING SIDE OPEN.

3. CUT A LONG STRIP OF PAPER SLIGHTLY LESS THAN ½ INCH WIDE. CURL THE PAPER AROUND A PENCIL. WRITE A SERIES OF IDEAS ON THE PAPER SEPARATING THEM WITH DOTTED LINES.

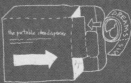

the portable idea dispenser

DREAMS STIC

4. HOLDING THE CURLED PAPER IN THE SHAPE OF A NUMBER NINE, PLACE IT INSIDE OF THE BOX MAKING SURE TO LEAVE A BIT STICKING OUT OF THE TOP. CLOSE THE BACK FLAP.

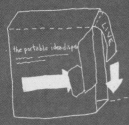

LIVE

the portable idea dispenser

5. PULL DOWN IDEA STRIP SO THAT IT REACHES THE BOTTOM OF THE BOX.

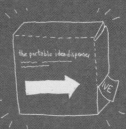

the portable idea dispenser

IVE

6. YOUR PORTABLE IDEA DISPENSER IS NOW READY. (YOU MAY WISH TO REINFORCE THE BOX WITH CLEAR PACKING TAPE.)

PORTABLE IDEA DISPENSER

MATERIALS: CARDSTOCK
PAPER (TEMPLATE ON PAGE 135)
PEN OR PENCIL

1. Cut out the template on page 135.

2. Follow instruction to assemble.

3. Fill in paper strip with ideas.

4. Install in a public place.

ALTERATIONS/ADDITIONS

MATERIALS: PAPER
WHEAT PASTE

1. Choose some additions from the template on page
 133. Cut them out.

2. Attach them using wheat paste to existing posters
 or other media.

ALTERNATE VERSION:
 Make a simple drawing with chalk. Affix the
 additions to your drawing.

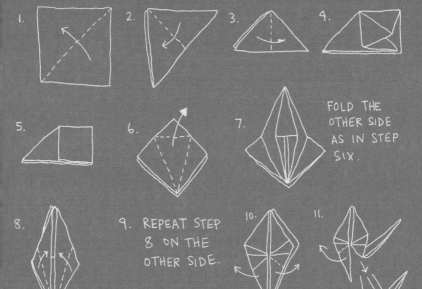

1.

2.

3.

4.

5.

6.

7. FOLD THE OTHER SIDE AS IN STEP SIX.

8.

9. REPEAT STEP 8 ON THE OTHER SIDE.

10.

11.

12. MAKE THE BEAK BY FOLDING TOWARD INSIDE.

13. PULL THE WINGS DOWN AND BLOW UP BODY THROUGH A HOLE UNDERNEATH.

FINISHED.

ORIGAMI ADDITIONS

MATERIALS: PAPER
STRING

1. Choose an origami format (crane, balloon, etc.).

2. Make multiples. This exercise is most effective if you do large numbers, 30 or more.

3. Find a place, such as a tree, that is appropriate for hanging this large group of objects.

THINK

question
everything
question
everything

BANNERS

FABRIC
FREEZER PAPER
FABRIC PAINT
SCISSORS
BRUSH

1. Come up with several ideas for fabric banners or flags. Consider, for example, creating some kind of celebration, printing quotes that are meaningful to you, or inciting a movement of some kind (such as guerilla gardening). The designs should be simple and use one color only.

2. Cut the fabric in a variety of shapes.

3. Make freezer paper stencils following the instructions on page 34.

4. Paint your designs onto the fabric.

5. Install your work in your choice of ways: attach it to a stick, hang it in a tree using string, attach it to existing flagpoles using paperclips, or string a bunch together to make a flag garland.

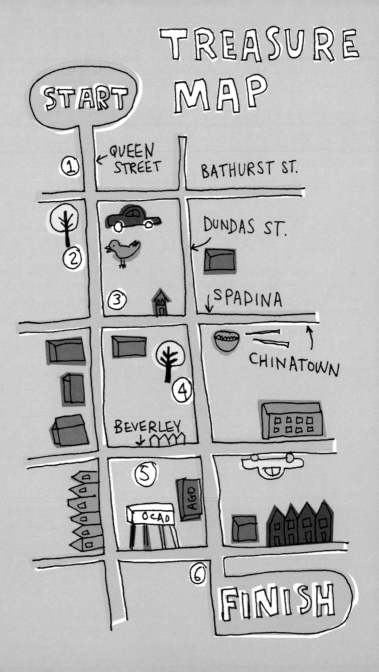

GUERILLA ART SCAVENGER HUNT

MATERIALS: A VARIETY OF YOUR OWN ARTWORK
PAPER
PEN OR PENCIL

1. Put up a series of guerilla art pieces all over a chosen neighborhood.

2. Create a map of the neighborhood and mark where the pieces are placed.

3. Either leave the map somewhere for people to find or hand it out to your friends (the latter is not so anonymous, but it is fun to do).

EXERCISES BY YOU

Find solutions for the following:

1. Transform garbage.
2. Direct the flow of people in an urban setting.
3. Document the passing of time.
4. Sell nothing.
5. Create decoration that is also information.
6. Celebrate an everyday object by giving it a new use in a public setting. For example, transform a plastic shopping bag.
7. Create a piece that is dependent on height.
8. Create a piece that incorporates one of the senses that you use the least.
9. Create pieces based on a recurring character.
10. Create a piece using one of your habits as a source.
11. Create a piece that answers the question, "if you only had one last chance to say something to the world, what would it be?"
12. Share little bits of your life one or two sentences at a time.
13. Open this book randomly and follow whatever instructions you turn to.
14. Instead of asking questions, give answers.
15. Create a piece based on light.
16. Create a piece based on sound.
17. Create a piece that is subtractive.
18. Work with the concept of "instant sculpture."
19. Create a piece that incorporates air.
20. Create a piece that is dependent on the rain.
21. Create a piece that changes over time.
22. Combine two of the above ideas.
23. Create a piece of guerilla art that is invisible.
24. Create a work and install it in a secret location.

GUERILLA ART FOR THE OFFICE

You can incorporate the use of guerilla art techniques to add life and a bit of mystery to any office setting. This practice helps encourage a light-hearted approach to your working life. You may have to take into account the fact that there are usually clean-up crews that sweep through at night who may do away with your creations. Anonymity is imperative. Proceed with the utmost secrecy.

1. Adhere paper cut-out footprints in hallways.
2. Post random quotes ("you look really good today") on the bulletin board.
3. Put stickers in the washrooms (see page 123).
4. Make mystery decorations (including flowers or plants).
5. Plant seed bombs outdoors in places that could use sprucing up.
6. Make little characters out of office supplies and leave them in unexpected places.
7. Offer mystery food (cookies, etc.) with a note attached.
8. Deposit an idea dispenser by the water cooler (see page 103).
9. Collect objects (such as colored soda lids) that are discarded in large quantities and incorporate them into some kind of installation. Add to the installation bit by bit over time.
10. Write notes with found objects (stones, etc.) on a regular basis.
11. Try the guerilla mail exercise on page 89. Instead of mailing the postcard, just circulate it around to your co-workers.

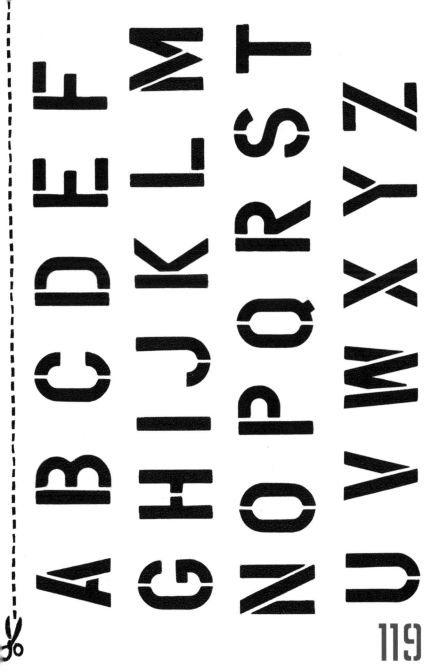

A B C D E F

G H I J K L M

N O P Q R S T

U V W X Y Z

119

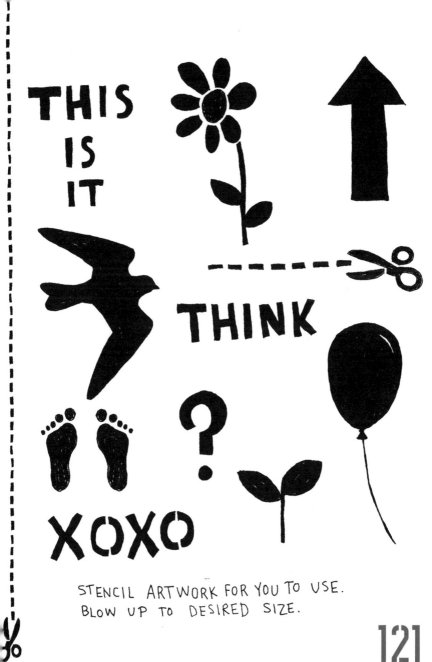

STENCIL ARTWORK FOR YOU TO USE.
BLOW UP TO DESIRED SIZE.

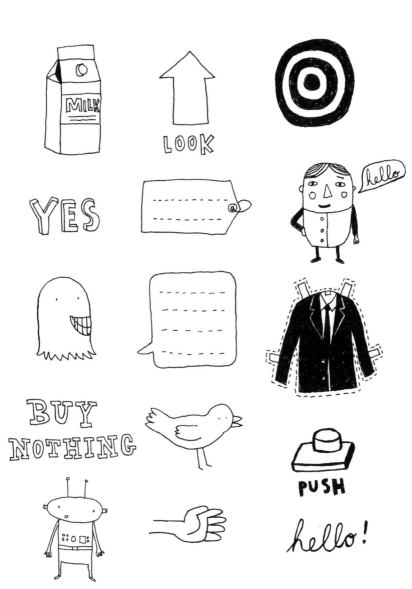

STICKER ARTWORK FOR YOU TO USE

123

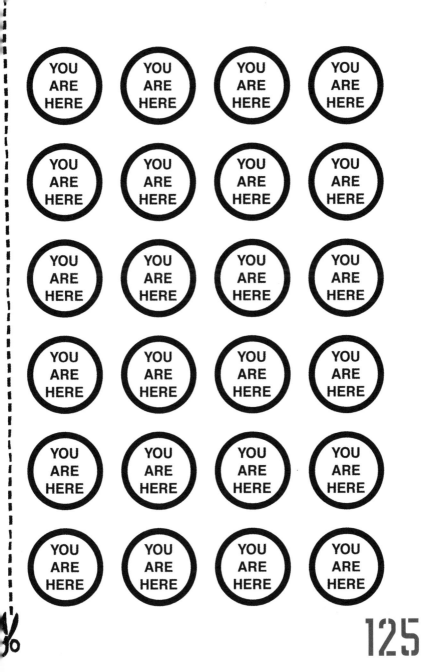

This book belongs to

- -

Please read and return (or pass on
as instructed). Vita sine.

date: - - - - - - - - - - - - - - - - -

This book now belongs to you.

It is a book that I (the previous owner)
enjoyed greatly and so I would like to pass it
on. Please read it (if you are drawn to do so).
If not you may just leave it where you found
it or pass it on to someone else.

Vita sine.

date: - - - - - - - - - - - - - - - - -

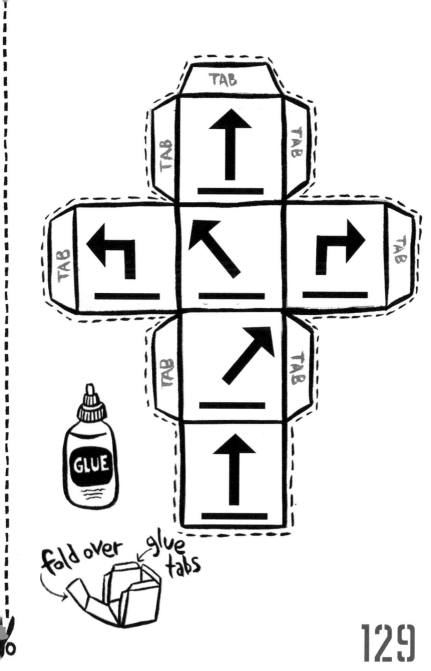

fold over glue tabs

129

TO WHOEVER FINDS THIS CARD...

THIS CARD IS A WORK OF ART.

YOU HAVE THREE CHOICES:

1. LEAVE IT WHERE YOU FOUND IT FOR SOMEONE ELSE TO FIND.

2. WRITE A NOTE, DO A DRAWING, DEFACE IT, ALTER IT (NOTE THE DATE AND WHERE YOU FOUND THE CARD).

3. GIVE THE CARD TO SOMEONE ELSE.

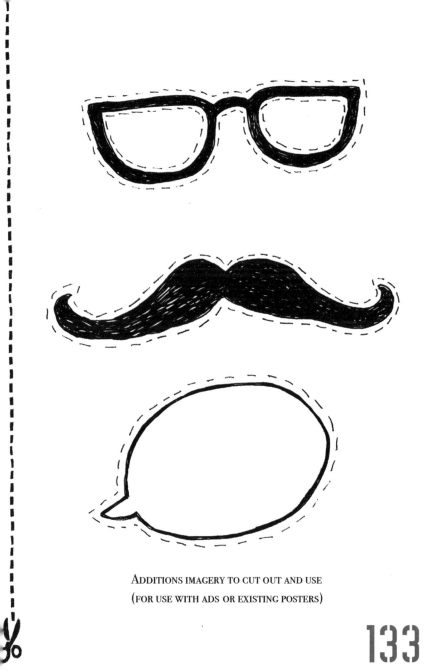

ADDITIONS IMAGERY TO CUT OUT AND USE
(FOR USE WITH ADS OR EXISTING POSTERS)

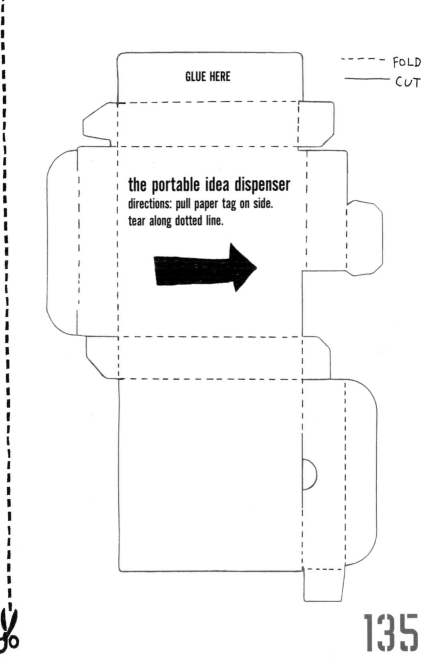

GLUE HERE

FOLD

CUT

the portable idea dispenser
directions: pull paper tag on side.
tear along dotted line.

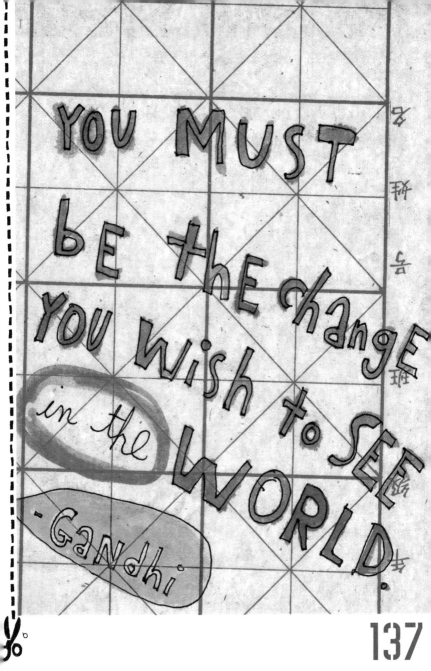

YOU MUST be the change YOU wish to SEE in the WORLD.

- Gandhi

137

Start your **OWN** REVOLUTION

infiltrate the masses

139

QUOTES FOR POSTCARDS, LEAVE-BEHINDS, OR WINDSHIELD FLYERS

"The greatest obstacle to understanding a work of art is trying too hard." —BRUNO MUNARI

Start your own revolution.

"The hardest thing to see is what is in front of your eyes." —GOETHE

"Do not be too timid about your actions, all life is an experiment." —RALPH WALDO EMERSON

"To pay attention is our endless and proper work." —MARY OLIVER

"There is no such thing as an empty space or an empty time. There is always something to see, something to hear." —JOHN CAGE

What you think of me is none of my business.

This is it.

"We cover the universe with the drawings we have lived." —GASTON BACHELARD

141

GLOSSARY

ALTERATION—the act of taking an existing item/medium (poster, billboard, object, etc.) and changing it in some way (usually through addition or subtraction) with the intent of creating new meaning or a new message.

CULTURE JAMMING—a form of public activism that involves taking existing mass media and altering it to produce new meaning (often the opposite of what was originally intended).

DETOURNEMENT—the artistic practice of taking elements from a source of well-known media and reusing it to create a new piece with different meaning. A French term that loosely translates to "turnabout."

DROP—the act of leaving or installing a guerilla art piece in public (as in "doing a drop").

FREEWAY BLOGGING (a.k.a. "roadway blogging")—the act of posting messages on or by public roadways in an effort to spread the word. Most commonly used for political protest on freeway overpasses, using large signs.

GRAFFITI (TAGGING)—a popular form of art whereby the artist leaves some form of drawing or words on a public (or sometimes private) surface. The concept of "tagging" refers to the artist "leaving his mark," often a repeated symbol or word that would be recognizable by viewers. This type of art began in the ancient Greek and Roman civilizations.

GUERILLA ART—any anonymous work (including but not limited to graffiti, signage, performance, additions, decoration) installed, performed, or attached in public or private spaces with the distinct purpose of affecting the world in a creative or thought-provoking way.

GUERILLA GARDENING—a form of non-violent action that involves a variety of methods including planting in public spaces or abandoned land under the premise of reclaiming land that has been neglected or misused and giving it a new purpose. It can also be used to beautify public spaces or to grow food.

FLASH MOB (also called "spontaneous gatherings")—an organized group of people who gather in a public place with the purpose of participating in a group activity for a short period of time and then disbanding. These meetings are planned and arranged using the Internet or digital communication networks. One example of a flash mob are the large-scale pillow fights that took place in San Francisco, London, and Toronto.

FOUND OBJECTS—any objects that you find out in the world. In guerilla art found objects are often given a new context different from their original intent.

HITCHHIKING—the act of installing a work of art in a public space. It is referred to as "hitchhiking" because often pieces are bolted to existing signposts or posted out of reach, making them difficult to remove. Another version might be "temporary hitchhiking"—temporarily installed works that are left for the purpose of being collected by art lovers.

INSTALLATION—a piece of art that requires the creator to assemble or install it.

KNIT TAGGING—using knitted pieces to "tag" public items such as trees, streetlight posts, car antennas, doorknobs, and park benches.

LIGHT GRAFFITI—graffiti made by either projecting something onto a building or public space, or by creating light-based art and sticking it somewhere publicly (one example of this is using magnets to stick LEDs to metal).

MEME—a thought, idea, concept, project, belief, etc. that is passed on and propagated

in a similar manner to a virus. The meme is subsequently altered, added to, and transformed. A form of group project commonly used in the realm of blogging to propagate ideas. Examples of memes might include phrases, questions, topics, songs, and public opinion.

MEME HACK—altering an existing meme to express an opposite position. An example of this might be a distortion of a corporate logo (see subvertising).

NONVIOLENCE—refers to a philosophy rooted in pacifism where social or political change is attained using a variety of techniques and without the use of violence, or extreme measures. Guerilla art may be considered a non-violent form of communication.

PERFORMANCE ART—a work that is "performed" in a public or private space, where the work itself consists of some kind of action, often involving the body in some way. Performance art has its roots in the realm of theatre.

PHENOMENOLOGY—a philosophical doctrine and method of study proposed by Edmund Husserl based on the premise that reality is created by perception or understood only in relation to human consciousness (as opposed to the study of things as they are).

PSYCHOGEOGRAPHY—an experimental form of movement in a public or non-public space that involves moving about the space in a non-habitual way. It may incorporate the element of chance to influence movement (such as the use of dice), or possibly movement based on a predetermined set of rules.

REALITY HACKING—an artistic practice and technique (stemming from hacking culture, contemporary art, activism, etc.) that involves a meaningful investigation of everyday objects and situations. Reality hackers are urban explorers, searching for meaning in the world around them. A method

of investigation might include a kind of public prank that causes others to question their own environment.

SITUATIONAL GRAFFITI—graffiti that uses what is existing in a space to build on, alter, or make jokes about the everyday usage of an object or space (for example, adding eyes to a fire hydrant, or writing notes on "how to use" a common everyday item).

STENCILING—a form of image-making consisting of cutting designs out of cardstock, paper, or some hard flat material, allowing the artist to create multiples of an image using paint or chalk in a short period of time.

SEED BOMBING (also known as "seed grenades")—a technique used in guerilla gardening where the gardener creates a "seed bomb," a small ball composed of clay, compost, and native seeds. The seed bombs are thrown into abandoned plots of land with the purpose of growing some form of vegetation (flowers, food, herbs). The intent may be one of political protest (against corporate ownership of land, urban development, etc.) or purely for beautification purposes.

STREET ART—any art created in or for the purpose of being displayed in public spaces. Forms of street art can include but are not limited to graffiti, installations, tagging, light art, wheatpasting, stenciling, stickers, and performance art.

SUBVERTISING—using the medium and format of advertising to propagate an alternate or opposite agenda, often in the form of parody, or political statement. Common formats include alteration of corporate logos or existing ads.

WHEAT PASTE—a solution made out of water and white flour that makes a strong paste used for hanging posters and a variety of other craft applications.

BIBLIOGRAPHY

Abram, David. *The Spell of the Sensuous.* New York: Vintage, 1997.

Annink, Ed and Ineke Schwartz, eds. *Bright Minds, Beautiful Ideas: Parallel Thoughts in Different Times.* Amsterdam: BIS Publishers, 2003.

Bachelard, Gaston. *The Poetics of Space.* Boston: Beacon Press, 1994.

Buchanan-Smith, Peter. *Speck: A Curious Collection of Uncommon Things.* New York: Princeton Architectural Press, 2001.

Hundertmark, Christian. *The Art of Rebellion: The World of Street Art.* California: Gingko Press, 2003.

Jacobs, Jane. *The Death and Life of Great American Cities.* New York: Vintage, 1992.

Kaprow, Allan. *Essays on the Blurring of Art and Life.* Edited by Jeff Kelley. California: University of California Press, 2003.

Kent, Corita and Jan Steward. *Learning By Heart: Teachings to Free the Creative Spirit.* New York: Bantam, 1992.

Oliveros, Pauline. *Deep Listening: A Composer's Sound Practice.* Nebraska: iUniverse, 2005.

Thompson, Nate and Gregory Sholette, eds. *The Interventionists: Users' Manual for the Creative Disruption of Everyday Life.* Massachusetts: MIT Press, 2004.

Trail, Gayla. *You Grow Girl: The Groundbreaking Guide to Gardening.* New York: Fireside, 2005.

ABOUT THE AUTHOR

Keri Smith is an author/illustrator turned guerilla artist. She has written several books, including *Living Out Loud: Activities to Fuel a Creative Life* (2003) and *Tear up this Book!: The Sticker, Stencil, Stationery, Games, Crafts, Doodle, And Journal Book For Girls!* (2005). She spends her days putting stickers up all over North America, collecting found paper clips, and searching for the perfect cup of tea. Read more on her website: www.kerismith.com.

WEBSITES

GUERILLA GARDENING
www.yougrowgirl.com
www.primalseeds.org
en.wikipedia.org/wiki/Masanobu_Fukuoka (the inventor of seed bombs)
www.storiesfromspace.co.uk (moss graffiti and more)

POSTERS, GRAFFITI CULTURE, STENCILING, AND STICKERS
www.woostercollective.com
www.stencilpirates.org
www.stickernation.net
www.ekosystem.org
www.stencilrevolution.com
www.stencilarchive.org
www.streetsy.com
www.graffitiproject.com/

SPEAKING OUT
www.adbusters.org (guerilla everything)

GUERILLA ACTIONS
www.rebargroup.org (conceptual guerilla art)
www.thewinterofthedance.com (guerilla movement/dance)
www.latourex.org/latourex_en.html (guerilla travel/tourism)
www.infoflow.com/larnie/dicewalk/index.html (dicewalk)

IDEAS
www.learningtoloveyoumore.com (lots of assignments)
www.stevelambert.com (conceptual artist)
www.harrellfletcher.com (conceptual artist)
www.mirandajuly.com (performance artist and filmmaker)
www.subk.net/mapsindex.html (maps project)
www.we-make-money-not-art.com/ (conceptual art blog. Note: not about making money)
www.antiadvertisingagency.com/ (guerilla advertising)
www.samarasproject.net/ (guerilla economy)
www.artinoddplaces.org (collective of artists)
www.glowlab.com (psychogeography)
www.fluxlist.com (fluxus movement)
www.quietamerican.org (sound exploration)
www.deeplistening.org (Pauline Oliveros)

HOW TO'S
www.tacticalsoundgarden.net/ (how to publish a wireless sound landscape)
www.makezine.com/blog (DIY everything)
www.graffitiresearchlab.com (DIY graffiti and more)
www.instructables.com (instructions for lots of things)